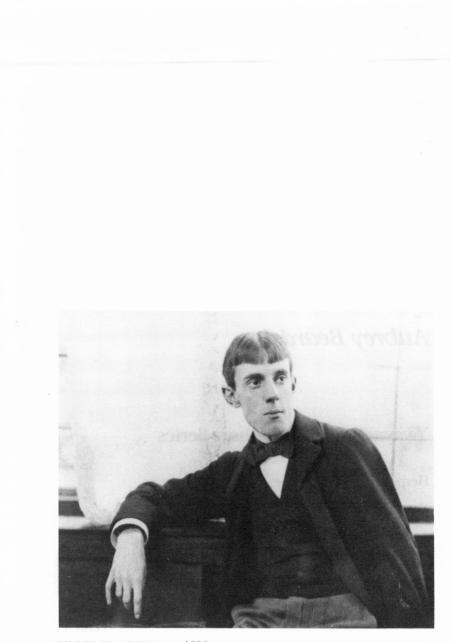

AUBREY BEARDSLEY, ca. 1890